LA DOLCE VITA

Inside the World of Dolce&Gabbana's Alta Moda Fashion Shows

LA DOLCE VITA

Inside the World of Dolce&Gabbana's Alta Moda Fashion S

Matt Lever

ACC ART BOOKS

Nª Sª
DO
Rosario
DA
Fátima

FOREWORD

Whenever I hear the first lilting strains of Pietro Mascagni's 'Intermezzo' from *Cavalleria Rusticana*, I am instantly transported to my front row seat at a Dolce&Gabbana fashion show. For many seasons, Domenico Dolce and Stefano Gabbana featured this evocative piece of music to open their catwalk presentations in Milan. It became a trademark soundtrack. The emotive musical interlude is not only a showstopping moment within the opera itself but, conjuring up images of DeNiro in *Raging Bull* or Pacino in *Godfather III*, has reached wider audiences via the cinema.

At its heart, a yearning paean to a yesteryear Italy that chimes perfectly with the designers' core ethos and aesthetic. So, it's not so surprising that Domenico and Stefano should choose this particular piece of music, as the pair don't just design clothes, they create moving pictures on their catwalks, whole worlds into which we are invited to enter.

Stefano once told me: 'We have always been fond of cinema, [which] has always been one of our most important sources of inspiration.'

Domenico continued: 'Our fashion is undoubtedly rooted into the great Italian and Mediterranean tradition, so I think it's natural that the icons of Neorealistic cinema are always present in our collections.'

Throughout their careers, the duo has presented equally epic filmic-style moments in their shows and carefully crafted advertising campaigns. Their designs create drama, starring a cast of alluring characters from Marpessa Hennink, Yasmeen Ghauri, Linda Evangelista, Tony Ward and David Gandy to latterly Nora Attal, Mun KaYoung, Colin Farrell and Miley Cyrus. Think of the melodramatic mini-movie advertising campaign for their fragrance, *Sicily*. Even as a grief-stricken Monica Bellucci follows her husband's coffin through the streets, she can't help flirting with a handsome mourner. It is this nostalgic imagery – a romantic snapshot of widow women, sunning themselves on their doorsteps; their rugged menfolk in tweed cloth caps and vests smoking in a nearby bar – with a frisson of sex always sizzling not far below the surface, which the pair have made their own. *Molto* sexy. An earlier campaign, again featuring Bellucci, this time in a wildly passionate homage to Federico Fellini's cult movie *La Dolce Vita*.

Domenico and Stefano present an alternative to everyday life. Real becomes reel. It is Sophia Loren in *Two Women* or Anna Magnani in *The Rose Tattoo*. Domenico and Stefano's passion for their *mestiere* becomes a theatrical experience in itself: enter stage right, a ballgown masterfully constructed from silken playbills for the *Teatro alla Scala*? Parasols and fans, crucifix and cameo, magi and madonnas. 'Now that Fellini, Rossellini, Pasolini and Visconti are gone, all we have is Dolce&Gabbana,' the other Madonna is reported to have said. Not surprising then that the singer chose to collaborate with the designers for her 'Girlie Show' tour in 1993.

In times of hardship, fashion inevitably looks to escape and nowhere is this notion more prevalent than in Dolce&Gabbana's Alta Moda fashion shows. Domenico and Stefano transport their audience, literally, to extraordinary worlds of palazzos and palaces, exquisitely tended gardens and abandoned gondolas, sea-front boardwalks and the cliff edge.

This glorious photographic portfolio by Matt Lever captures perfectly the lavish, illusionary narrative as stage directed by the designers. From the hands-on cutting and sewing of gowns in the making, to the added backstage drama of hair and make-up and meticulous styling: the glittering jewel-box accessories that gleam in the setting sun, the bouquets of flowers that become a lush headdress or trail a hem. Amid clouds of tulle, painted silk, bejewelled lace and emblazoned tapestry, Dolce&Gabbana's Alta Moda offers fireworks on the catwalk and, quite literally, in the balmy night sky that hangs heavy as another show-stopping, operatic fashion moment is set adrift on memory bliss…

Professor Iain R Webb – writer, curator, academic.

INTRODUCTION

In 2012, when Dolce&Gabbana asked me to photograph their first Alta Moda show, held in Taormina, Sicily, I really didn't know anything of the world I would be immersed into. I was no stranger to fashion shows – I had been shooting ready-to-wear shows for British *Elle* since 1998 – but this was like nothing I had ever experienced before.

The Dolce&Gabbana Alta Moda experience is something very unique. It takes place over a whole weekend, with not just the fashion show but also firework displays, meals and a party on the last night. Most fashion shows, even within *haute couture*, are usually fast-paced affairs; it happens and then everyone moves on to the next show. But Alta Moda guests are completely submerged in the opulent Dolce&Gabbana brand.

Another feature of the Alta Moda shows is how extraordinarily personal they feel. The fact that there were hardly any photographers or journalists at the first few seasons was a testimony to how exclusive the whole occasion was. There is something quite special (certainly nowadays) about experiencing things that not many other people will see. It also allowed the events to become artistic expressions, rather than pure brand-building exercises.

I called this book *La Dolce Vita* because that's exactly what Alta Moda represents: 'The Sweet Life'. The Alta Moda shows are always so exquisite, the locations are breathtaking and the soundtrack is beautiful. The models usually enter the runway to the fervent sounds of opera. Coupled with the magnificent backdrop of wherever the show is, be it on a cliff in Capri, St Mark's Square in Venice or inside the Teatro alla Scala in Milan, it makes for the most intoxicating experience.

Being at the very first Alta Moda and seeing the inception of the designers' dream will always be an incredible memory, but another moment that stands out is evident in the photograph of the yellow dress and the umbrellas on the red carpet. This was taken at the Venice show in 2021. Just as the models were about to go out for the finale, heavy thunderclouds rolled in, the heavens opened and a double rainbow appeared. We knew the storm was coming and the show had been brought forward to avoid it. But as it happened, the timing was almost perfect. The whole show was outside but what should

have ruined all the hard work and careful planning actually ended up making for an unbelievable spectacle. And I was lucky enough to capture the one lighting strike of the evening in that image.

I wanted this book to be a visual and emotional journey through the Alta Moda world, rather than just a catalogue of clothes; for you to feel what it's like to be there, rather than just having a document of the outfits; to take you deeper into the world of Dolce&Gabbana's Alta Moda; and to share the full depth of their recurring love letter to Italy.

25

35

41

53

57

INTIMO NUDO

119

143

MDLXXVI

ADORAMUS TE CHRISTE
ET BENEDICIMUS TIBI QUIA
PER SANCTAM CRUCEM TUAM
REDEMISTI MUNDUM

195

203

215

223

251

261

286

297

p. 5 Capri, July 2014

pp. 10-11 Stefano Gabbana, Kate King, Domenico Dolce, Milan, January 2013

pp. 12-13 Taormina, July 2012

pp. 14 & 15 Taormina, July 2012

pp. 16-17 Portofino, July 2015

pp. 18 & 19 Taormina, July 2012

p. 21 Kate King, Venice, July 2013

p. 22 Ophelie Guillermand, Milan, January 2015

pp. 24-25 Jane Grybennikova, Stasha Yatchuk, Portofino, 2015

pp. 26-27 Domenico Dolce, Kate King, Stefano Gabbana, Milan, January 2013

pp. 28-29 Taormina, July 2012

pp. 30-31 Milan, December 2019

p. 32 Bette Franke, Taormina, July 2012
p. 33 Taormina, July 2012

pp. 34-35 Taormina, July 2012

pp. 36-37 Capri, July 2014

p. 38 Venice, July 2013
p. 39 Giulia Manini, Venice, July 2013

pp. 40-41 Amilna Estevao, Portofino, 2015

pp. 42 & 43 Milan, January 2015

pp. 44-45 Bianca Balti, Taormina, July 2012

pp. 46-47 Portofino, July 2015

p. 48 Anastasia Lagune, Portofino, 2015
p. 49 Anna Grostina, Milan, January 2015

pp. 50-51 Stefano Gabbana & Domenico Dolce, Milan, January 2013

pp. 52 & 53 Taormina, July 2012

p. 54 Portofino, July 2015
p. 55 Taormina, July 2012

pp. 56-57 Yifei Li, Portofino, 2015

pp. 58-59 Giulia Manini, Bianca Balti, Taormina, July 2012

pp. 60-61 Capri, July 2014

p. 62 Nadja Bender, Agne Konciute, Capri, July 2014
p. 63 Capri, July 2014

p. 64 Milan, January 2015
p. 65 Sophie Rask, Lake Como, July 2018

pp. 66-67 Milan, January 2015

p. 69 Venice, July 2013

pp. 70-71 Capri, July 2014

pp. 72 & 73 Capri, July 2014

pp. 74-75 Kate King, Taormina, July 2012

p. 76 Julija Step, Portofino, 2015
p. 77 Portofino, July 2015

pp. 78-79 Giulia Manini, Portofino, July 2015

p. 80 Giulia Manini, Portofino, July 2015
p. 81 Sasha Luss, Portofino, July 2015

pp. 82-83 Capri, July 2014

p. 84 Giulia Manini, Napoli, July 2016
p. 85 Josephine le Tutour, Portofino, July 2015

p. 86 Elisabeth Erm, Capri, July 2014
p. 87 Nicole Pollard, Capri, July 2014

pp. 88-89 Taormina, July 2012

pp. 90-91 Ginta Lapina, Capri, July 2014

p. 92 Elisabeth Erm, Maartje Verhoef, Capri, July 2014
p. 93 Capri, July 2014

pp. 94-95 Bianca Balti, Taormina, July 2012

p. 96 Ava Smith, Venice, July 2013
p. 97 Nicole Pollard, Venice, July 2013

p. 98 Anabela Belikava, Valery Kaufman, Venice, July 2013 p. 99 Kate Bogucharskaia, Mina Cvetkovic, Portofino, 2015

pp. 100-101 Milan, January 2015

p. 102 Taormina, 2012
p. 103 Stephanie Joy Field, Portofino, 2015

pp. 104-105 Diana Tieplova, Milan, 2016

p. 106 Milan, January 2015
p. 107 Portofino, July 2015

p. 109 Jac Jagaciak, Venice, July 2013

pp. 110-111 Giulia Manini, Milan, January 2014

pp. 112-113 Eva Berzina, Milan, January 2014

pp. 114-115 Giulia Manini, Karolina Smetek, Lake Como, July 2018

pp. 116-117 Alicia Holtz, Lake Como, July 2018

p. 118 Milan, January 2016
p. 119 Kinga Rajzac, Portofino, July 2015

pp. 120-121 Ophelie Guillermand, Diana Moldovan, Milan, January 2015

p. 122 Sara Dijkink, Venice, July 2021

p. 125 Marie Kone, Venice, July 2021

pp. 126-127 Capri, July 2014

pp. 128-129 Nikki Vonsee, Venice, July 2021

pp. 130-131 Portofino, July 2015

pp. 132-133 Milan, January 2016

pp. 134-135 Taormina, July 2012

p. 136 Frankie Herbert, Lake Como, July 2018
p. 137 Capri, July 2014

pp. 138-139 Portofino, July 2015

pp. 140-141 Milan, January 2016

pp. 142-143 Yue Han, Milan, January 2017

pp. 144-145 Portofino, July 2015

pp. 146-147 Ginta Lapina, Maartje Verhoef, Capri, July 2014

pp. 148-149 Giulia Manini, Capri, July 2014

pp. 150-151 Frankie Herbert, Lake Como, July 2018

pp. 152-153 Portofino, July 2015

pp. 154-155 Giulia Manini, Capri, July 2014

pp. 156-157 Antonina Vasylchenko, Capri 2014

pp. 158-159 Anastasia Lagune, Julia Van Os, Karolina Gorzala, Portofino, July 2015

pp. 160-161 Marie Kone, Venice, July 2021

pp. 162-163 Milan, December 2019

pp. 164-165 Milan, January 2013

pp. 166-167 Taormina, July 2012

pp. 168-169 Milan, December 2019

p. 170 Milan, January 2013

p. 173 Ophelie Guillermand, Milan, January 2014

p. 174 Ophelie Guillermand, Milan, January 2014
p. 175 Maartje Verhoef, Capri, July 2014

pp. 176-177 Nastya Sten, Portofino, July 2014

pp. 178-179 Portofino, July 2015

p. 180 Sasha Luss, Portofino, July 2015
p. 181 Capri, July 2014

pp. 182-183 Taormina, July 2012

pp. 184-185 Guido Palau, Kate King, Milan, January 2013

pp. 186-187 Portofino, July 2015

pp. 188-189 Yumi Lambert, Wangy, Napoli, July 2016

pp. 190-191 Kinga Rajzac, Milan, January 2015

pp. 192-193 Portofino, July 2015

pp. 194-195 Zuzanna Bijoch, Capri, July 2014

p. 196 Venice, July 2013
p. 197 Maud Welzen, Venice, July 2013

pp. 198-199 Sasha Luss, Milan, January 2015

pp. 200-201 Taormina, July 2012

p. 202 Wanessa Bicalho, Milan, January 2015
p. 203 Diana Moldovan, Maja Salamon, Milan, January 2015

pp. 204-205 Milan, January 2015

p. 206 Ava Smith, Venice, July 2013

pp. 208-209 Blanca Padilla, Milan, January 2015

p. 210 Milan, January 2014
p. 211 Sasha Luss, Milan, January 2015

pp. 212-213 Rose R, Anastasiia Koval, Milan, December 2019

pp. 214-215 Ophelie Guillermand, Milan, January 2015

p. 217 Zlata Mangafic, Milan, January 2014

pp. 218-219 Guido Palau, Yumi Lambert, Milan, December 2019

p. 220 Giulia Manini, Milan, January 2014
p. 221 Maud Welzen, Milan, January 2014

pp. 222-223 Jess Picton Warlow, Portofino, 2015

p. 224 Taormina, July 2012
p. 225 Yuliya Paul, Taormina, 2012

pp. 226-227 Milan, January 2016

pp. 228-229 Jane Grybennikova, Milan, January 2015

pp. 230-231 Auguste Abeliunaite, Irina Liss, Tabitha Simmons, Milan, January 2014

p. 232 Venice, July 2013
p. 233 Milan, January 2014

p. 234 Sasha Luss, Milan, January 2014

pp. 236-237 Stefano Gabbana, Ginta Lapina, Taormina, 2012

pp. 238-239 Domenico Dolce, Taormina, July 2012

pp. 240-241 Nuri Son, Yi His Chen, Jina You, Milan, December 2019

pp. 242-243 Mina Cvetkovic, Capri, July 2014

p. 244 Giulia Manini, Milan, January 2014
p. 245 Capri, July 2014

p. 246 Muriel Beal, Venice, 2013

p. 249 Milan, December 2019

pp. 250-251 Giulia Manini, Milan, January 2014

p. 252 Ine Neefs, Milan, January 2014

p. 254 Ginta Lapina, Capri, July 2014
p. 255 Blanca Padilla, Josephine le Tutour, Portofino, July 2015

p. 256 Milan, January 2014
p. 257 Blanca Padilla, Wanessa Bicalho, Milan, January 2015

p. 258 Nicole Pollard, Capri, 2014
p. 259 Zuzanna Bijoch, Milan, January 2014

pp. 260-261 Josephine le Tutour, Venice, July 2013

pp. 262-263 Antonio Pino, Domenico Dolce, Taormina, July 2012

p. 264-265 Antonina Vasylchenko, Venice, July 2013

p. 267 Blanca Padilla, Josephine le Tutour, Portofino, July 2015

pp. 268-269 Jac Jagaciak, Venice, July 2013

pp. 270-271 Zlata Mangafic, Milan, January 2014

pp. 272-273 Giulia Manini, Napoli, July 2016

pp. 274-275 Tabitha Simmons, Venice, July 2013

p. 276 Tabitha Simmons, Taormina, July 2012
p. 277 Guido Palau, Taormina, July 2012

pp. 278-279 Anna Piirainen, Erjona Ala, Venice, 2013

p. 280 Karen Elson, Venice, July 2013
p. 281 Sasha Luss, Milan, January 2014

p. 283 Kate King, Alex Yurieva, Patrycja Gardyagjlo, Agne Konciute, Venice, 2013

pp. 284-285 Domenico Dolce & Stefano Gabbana, Venice, July 2013

pp. 286-287 Zuzanna Bijoch, Ros Georgiou, Venice, 2013

pp. 288-289 Zuzanna Bijoch, Milan, January 2014

p. 291 Wangy, Napoli, July 2016

p. 292 Zlata Mangafic, Milan, January 2014

pp. 294-295 Ala Sekula, Venice, July 2021

pp. 296-297 Capri, July 2014

pp. 298-299 Milan, December 2019

pp. 300-301 Napoli, July 2016

pp. 302-303 Portofino, July 2015

p. 304 Capri, July 2014

pp. 306-307 Napoli, July 2016

ACKNOWLEDGEMENTS

I would like to thank Domenico and Stefano for involving me in their incredible Alta Moda shows, for creating such unbelievable outfits and also for supporting this book. A huge thank you to Iain R Webb, who was an immense help in getting this book to press, for his beautiful words and for believing in me all those years ago. I would also like to thank Ludovica Zanotti for her tireless support and Cristina Apa for her endless help in making this book happen. Also, to Domenico Giandinoto, Giorgio Forestiero, Gianluca Gagino, Stefania Alafaci. Thank you to casting genius Decio Santo for meticulously making sure the models were represented in the book, and of course to all the models and their agents for their unbelievable generosity in allowing me to use their images in the book. A huge amount of respect to Guido Palau, Dame Pat McGrath, their talented crews and to Tabitha Simmons for helping bring these spectacles to life. Thank you so much to all the kind people at ACC Art Books for taking this book on and being so incredibly helpful, and easy to work with.

Finally, thank you to Mum, Beanie, Lily and Max.

© 2025 Matt Lever
World copyright reserved

ISBN: 978 1 78884 292 1

The right of Matt Lever to be identified as author of this work has been asserted by him in accordance with the Copyright, Designs and Patents Act 1988

All rights reserved. No part of this publication may be reproduced, stored in a retrieval system, or transmitted in any form or by any means electronic, mechanical, photocopying, recording or otherwise, without the prior permission of the publisher

A CIP record for this book is available from the British Library

The author and publisher gratefully acknowledge the permission granted to reproduce the copyright material in this book. Every effort has been made to trace copyright holders and to obtain their permission for the use of copyright material. The publisher apologises for any errors or omissions in the text and would be grateful if notified of any corrections that should be incorporated in future reprints or editions of this book

Editors: Susannah Hecht & Stewart Norvill
Designer: Craig Holden
Reprographics: Corban Wilkin

FSC® C019910
MIX
Paper | Supporting responsible forestry
www.fsc.org

Printed in China
for ACC Art Books Ltd., Woodbridge, Suffolk, UK

www.accartbooks.com

ACC ART BOOKS